Encaustic Mixed Media Collage
One Artist's Approach

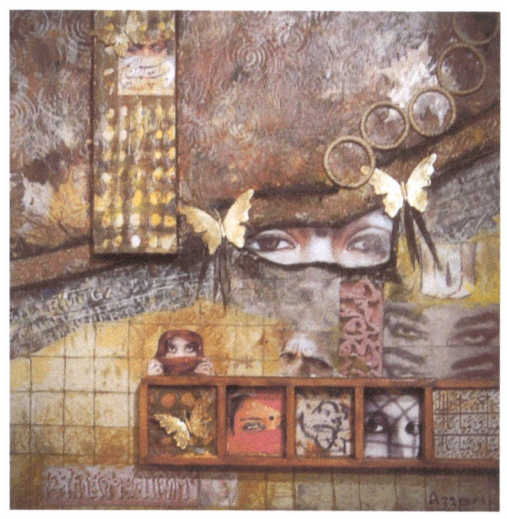

Ken Azzari

Copyright © 2013 Ken Azzari

All rights reserved.

ISBN-13: 978-1492129035
ISBN-10: 1492129038

Acknowledgements

 I would like to acknowledge my high school art teacher, Umberto Carozza, for instilling in me the love of art. To him, art was a serious academic pursuit, and he treated us as if he were teaching college students, never talking down to us or expecting less from us because of our age. He not only taught us how to make art but also taught us to understand its history and meaning. Every Friday was art history day. He essentially gave us the equivalent of first-year college art history. I left high school with a portfolio of art that I created in his class and with an understanding of why artists made art and how art had progressed in Western civilization. He took advantage of unique resources in New York, such as borrowing representative works by famous artists from the Metropolitan Museum of Art. We pored over these works of art, examining the artists' techniques, the art periods they represented, and what the artists were saying.

 He taught us that art was more than making pretty pictures of things we observe around us; it had to be creative and not imitative. Art also had to express the artist's unique view of the world. He exposed us to different periods in art and opened our minds to innovation, experimentation, and the creative process. He gave his students a gift that we all appreciated.

 I would also like to thank my sister-in-law, Holly Azzari, for the extra editorial help I needed to get this book to print. Her assistance was invaluable.

Contents

Section 1 Page 7
Foreword Page 9
My Approach to Encaustic Art Page 11

Section 2 Page 13
Artworks Page 14

Appendixes Page 43
Appendix 1. Encaustic Tips Page 45
Appendix 2. Resources Page 49
Appendix 3. Biography Page 51

Section 1

1. Foreword

2. My Approach to Encaustic Art

Foreword

Encaustics is an exciting art medium that offers artists unlimited ways of expressing their creativity. The word "encaustic" derives from the Greek word *enkaustikos*, which means "to burn in." The Greeks invented this method around 500 BC. It consists of natural beeswax mixed with dammar resin (crystallized tree sap). The resin makes the wax harder and more durable by raising the mixture's melting point.

The Greeks initially used the wax mixture to waterproof the bottoms of their warships. Soon they tinted the wax with colored pigments and decorated the ships with brightly colored markings. Homer referenced the presence of these painted ships during the Trojan War. Some ship painters refined the process and began to use encaustics to paint pictures, usually on wood panels.

The use of encaustic paint rivaled the use of tempera paint, the oldest paint media used by artists. Being a water-based paint, tempera paint was not very durable, whereas encaustic paints actually preserved the works of art. Greek artists and artisans began to use it to decorate architecture, paint pictures, and adorn statuary, which we often see as pure-white marble in museums and books.

Encaustic painting was introduced to Egyptian culture when Alexander the Great conquered Egypt in the fourth century BC. After this, a substantial population of Greeks inhabited Egypt for three centuries; as a result, some parts of Egyptian culture permeated the Greek ethos. This can clearly be seen in the adoption of mummification and in the Fayum funeral portraits painted by Greek artists (see illustrations next page). In fact, these funeral portraits are perhaps the best-known examples of encaustic painting from ancient times. Artists portrayed the deceased either in his or her prime or after death. The portrait was then placed over the person's mummy as a memorial. Many of these portraits have survived time with colors as fresh as if they were painted today.

As an artistic medium, encaustics fell out of favor during the economic upheaval that occurred with the fall of the Roman Empire. Icon painting preserved this method up to the twelfth century, but it generally became a lost art. It enjoyed a small resurgence in the eighteenth century when amateurs discovered the ancient technique and used it as a novelty. Although encaustics were used in the nineteenth century to solve problems of mural painters in damp northern climates, the technique remained an obscured art form as a whole. Over time water based paints would run on the damp walls, whereas encaustic paint preserved the image.

In the twentieth century, when electric heating implements and a variety of tools made encaustic painting less cumbersome, this medium made a comeback. Artists such as Diego Rivera and Jasper Johns experimented with it, thus reviving interest in the technique. It is once again taking a formidable place among artists. Its visual and physical properties and the range of texture and color possibilities make encaustic painting uniquely compatible with many contemporary styles.

Mattera, Joanne. *The Art of Encaustic Painting*. New York: Watson-Guptill Publications, 2001

Mayer, Ralph. *The Artist's Handbook of Materials and Techniques*. Viking Adult; 5th ed. 1991

Reams, Maxine. " Unique Wax Paintings by Immigrant Artists Endure 10,000 Years." *LA Times*, Oct.19, 1952

"Encaustic Painting." Wikipedia: the free encyclopedia, Wikipedia Foundation Inc., last updated 19 August 2013. Accessed 19 August 2013. <en.wikpedia.org/wiki/encaustic- painting>

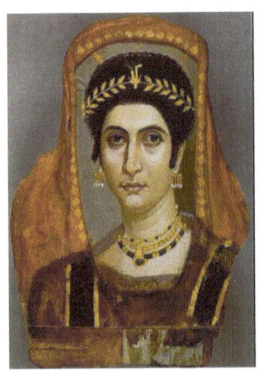
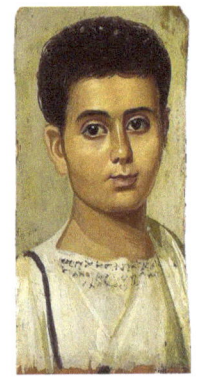
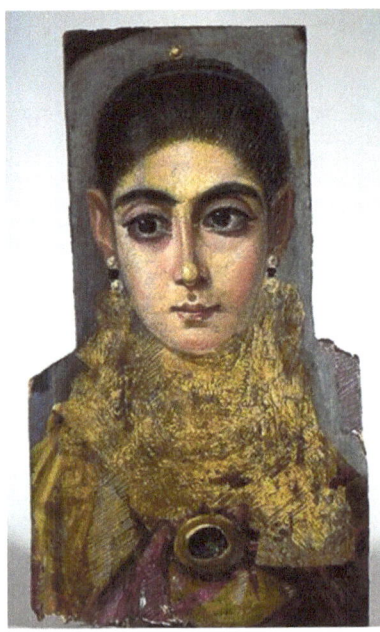

The Mysterious Fayum Portraits: Faces from Ancient Egypt

These encaustic paintings were painted between the first century BC and the third century AD. The Egyptian climate allowed them to survive intact. Similar Hellenistic paintings were produced in many places that were part of the Roman Empire, but abundant examples were only found in Fayum. These paintings represented the deceased.

2. My Approach to Encaustic Art

After a career as an art teacher and school administrator, during which time I made little art, I searched for an artistic vision to inform my art. I explored the usual media and techniques, painted figuratively and non figuratively, and experimented with mixed media and collage. For a year I struggled to find a clear reason to make my art; however, I recognized I was drawn to mixed media and collage more than traditional painting. I read about encaustic painting and became more and more interested in the medium. I bought fifty or sixty dollars' worth of the cheapest tools and commercially available encaustic paints and began to experiment.

I soon realized the versatility inherent in the medium. Unlike oils and acrylics, you can spread layers of colored wax and then scrape them back to reveal portions of layers beneath the topcoat. The translucent quality creates depth by fogging the colors or shapes beneath each layer. Transparent colors can be made by adding more medium to the color, similar to adding more water to watercolors. I was intrigued by how well suited the medium is for mixed media, collage, and assemblage.

Texture, whether visual or tactile, has always been of great interest to me. It adds interest in any work of art. With encaustics, depending upon how you apply the medium, a piece can be rich in different textures. You can apply the heated wax thickly or thinly in different areas of the painting, creating hills and valleys. You can scratch it, carve it, or stencil it, thus creating more textural interest. Apply it over a cloth, such as lace, and create a different texture. Specialty papers have distinct visual and tactile textures; when added to a work, they create interest, variety, and color. The possibilities are endless, and my body of work illustrates many of them.

Color (or lack of color) is an important element in any work of art. I use color to create a mood, to add interest, and sometimes to surprise. Again, encaustic painting proves to be very compatible with various other media. You can create your own palette of encaustic colors by adding ground pigment to the medium in small tin cups. You can achieve similar results by adding different colors of oil paints to the medium. To combine colors, you can arrange tins of paint around the edges of a heated electric griddle, leaving space to carry out the mixing.

Because encaustic painting is compatible with other media, I have created many mixed media images that incorporate oil sticks, oil pastels, watercolors, pastel chalks and charcoal, glue, shellac, and inks (not an exhaustive list). Experimenting in this way produces distinctive and surprising results. My work relies on all these variables to create unique and original images. In essence, after struggling with different traditional media and techniques, encaustics informed the vision of what I wanted to say with my art.

As important as it is to learn techniques and to master media, I believe that having something to say with your art is the primary factor that separates someone who casually makes pictures from an artist. During the Renaissance, for example, artists solved the problem of rendering space by perfecting perspective. These artists usually depicted biblical themes that represented religion or social circumstances of the noble and rich. They communicated ideas that moved art forward. Inventiveness, discovery, and the communication of ideas permeate art history in all human cultures, from primitive art to the art that is being created today. When I make art, I too am communicating ideas—sometimes obviously and sometimes subtly. Equality, equity, culture, and the environment are issues that often creep into my work.

Along with my works of art on the following pages, I included my thoughts and the process I used for each piece. As I gather the raw materials, I often do not know what the result will be. However, these items inform the outcome. I enjoy the process of creating something and figuring out what to make as much as the final result. My work is not a reflection of things or objects I am observing; the pieces are objects or things in themselves. I hope you enjoy what I have created.

Note: On the off chance that I have inspired you to try encaustics, I included a list of basic tools and equipment to get you started inexpensively. See Appendix A

Section 2

Artworks

1. *India Eyes*
2. *Time Flies Whether or Not Fun is Involved*
3. *Making Time*
4. *International Symbol of a Bear in Distress*
5. *Class of '64*
6. *Underwood*
7. *Hands of Mud, Love, and Faith*
8. *Not Another Flag Painting*
9. *Letters and Numbers*
10. *Grid*
11. *Underwood 2*
12. *50 Points*
13. *Equality*
14. *Yes Virginia, Climate Change is Real*

India Eyes

22" x 22"

Encaustic Mixed Media Collage

Since 9/11, it seems as though Americans stereotype all people from the Middle East. You often hear the news reporting that someone said or did something harmful to a person wearing a turban even though the person likely had nothing to do with the terrorists who struck the World Trade Center. In contrast, I felt that it was important to say something positive about people in that region who have no terrorist intentions. *India Eyes* is the result of this desire.

The piece is also an excellent example of my approach to my art—that is, my process. I started with a clear coat of the encaustic media on a piece of birch plywood. Not knowing what the result would be, I moved pieces of photos and three-dimensional objects around the picture plane. When the composition became apparent, I searched the Internet for examples of Indian calligraphy and more pictures of eyes to include. I selected the decorative paper and lace scraps that fit within the visual theme and that added a rich variety of visual and tactile textures. The gold butterflies as well as the rings and the wooden box at the bottom right were a great finds in a local thrift store.

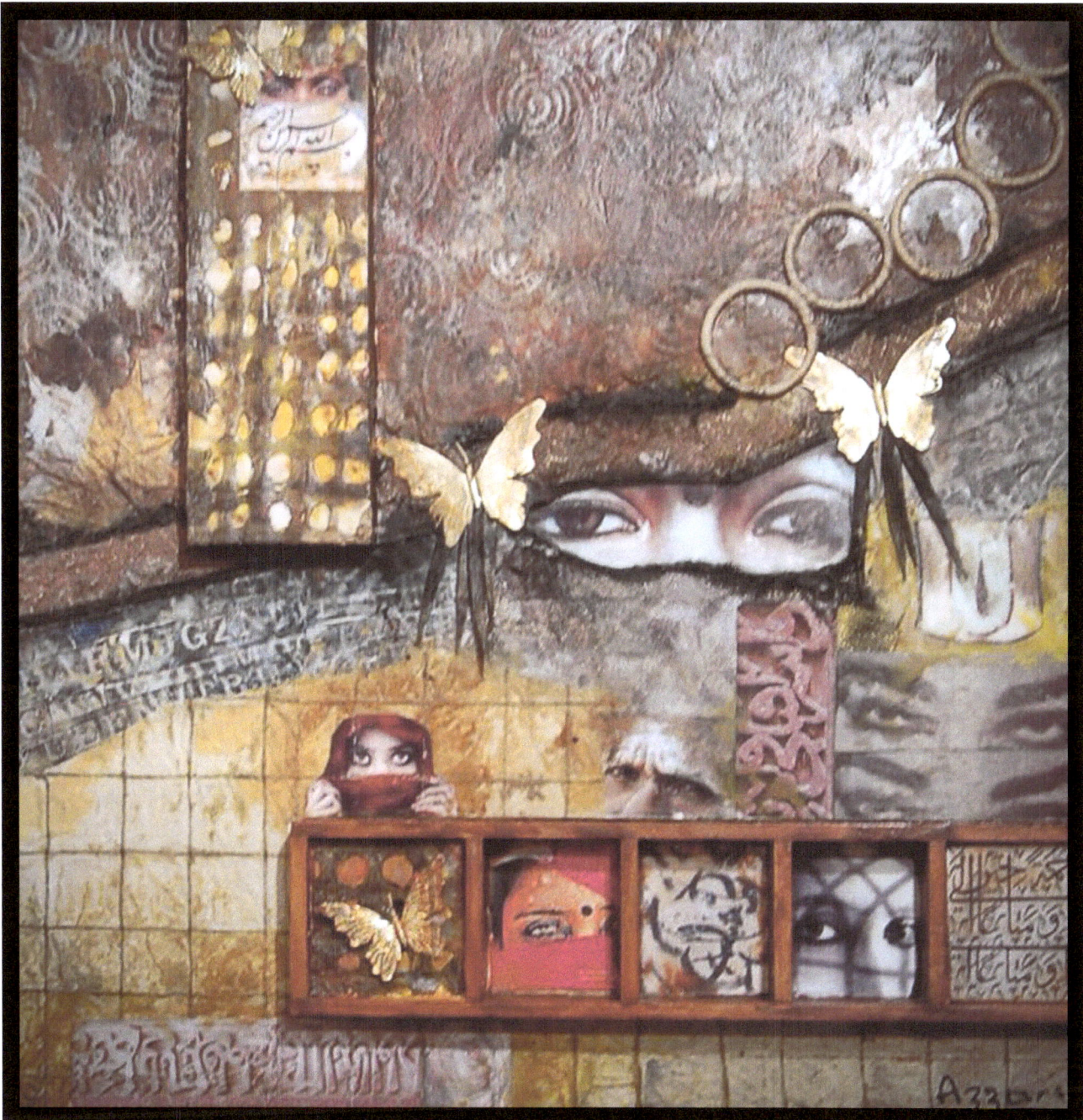

Time Flies Whether or Not Fun Is Involved

17" x 21"

Encaustic Mixed Media Collage

Time Flies Whether or Not Fun Is Involved was the first mixed media encaustic painting I made after practicing many of the different possibilities inherent to the technique. I created this piece for the first annual self-portrait show presented by the Taos Center for the Arts in Taos, New Mexico.

The theme came to me immediately because it is a portrait of me. I decided to be a little more obscure and perhaps more revealing in the process. I chose to symbolically represent myself using reverse (negative) photo images, indicating my constant presence within the work. The title describes exactly how I felt at the time. After years of work, raising my kids, and dealing with all of the positive and negative life events, this piece demonstrates a cathartic realization that those experiences were suddenly behind me.

Technique wise, I applied various types of cloth and covered them with encaustic paints. I scraped back certain areas to reveal the texture the lacy fabric created. The words were first printed on my computer, as were the negative images. I applied them with clear encaustic medium and smoothed them out with a flatiron. This allowed the background color to bleed into the paper the words were printed on. The composition was built up with layers of wax that were fused together using a heat gun.

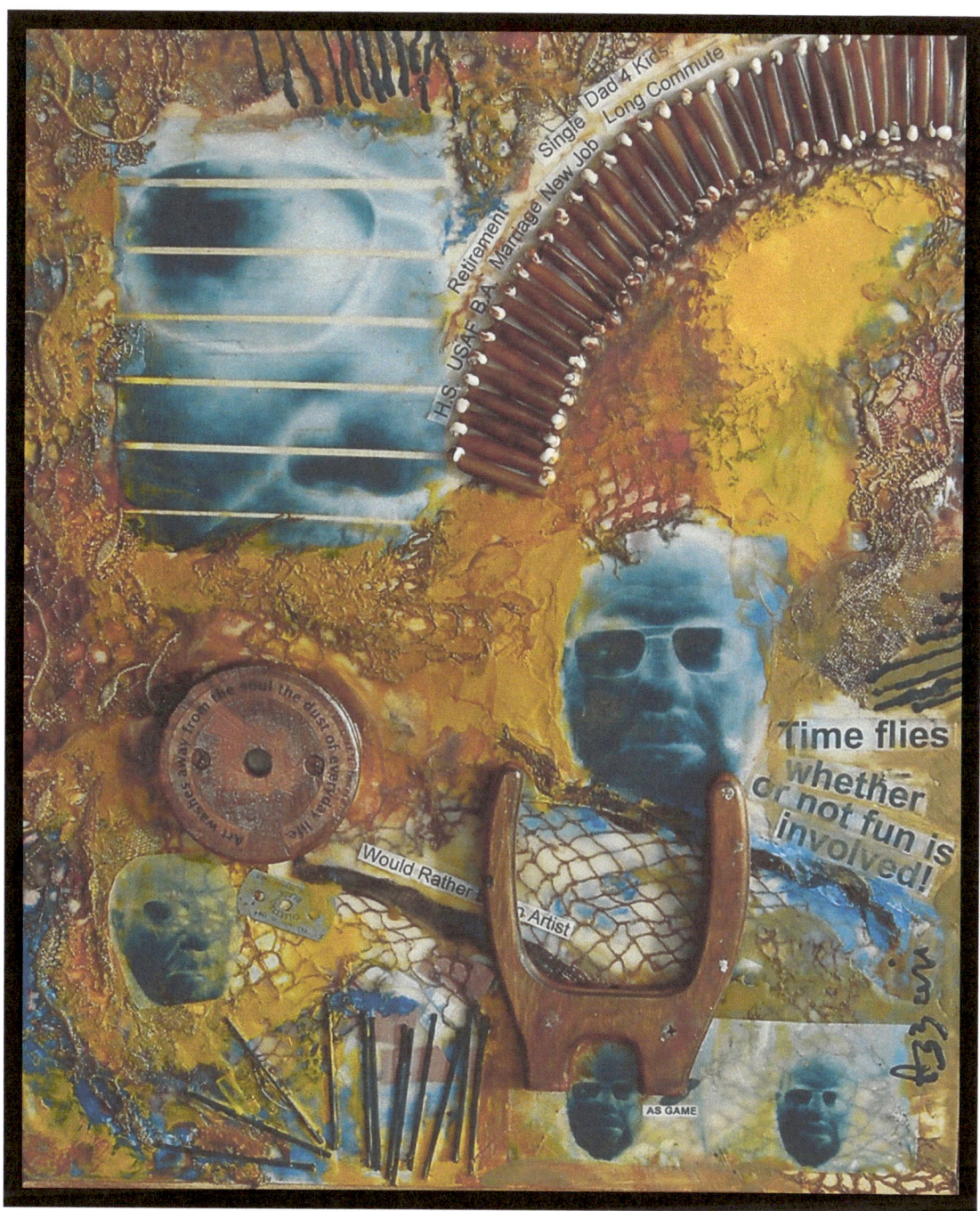

Making Time

22" x 22"

Encaustic Mixed Media Collage

Making Time began when I acquired a broken inner mechanism from a grandfather clock at a relative's home. It was a bronze mechanism, and it had an irresistible shine. As I dismantled it, I began to think about the many different ways time is expressed in our lives. I decided to take these differences and combine wordplay with the workings of an instrument that keeps accurate time. The chimes from the grandfather clock reminded me that musicians keep time as well.

Time zones correlate with the rotation of the earth around the sun. Consequently, when the sun is at its highest point in the sky, it is considered solar noon at that place on earth. Greenwich mean time (Greenwich, England), however, is used by the military, air traffic control, and for other scientific applications. By using this geographic spot on earth and a twenty-four-hour clock, time all over the world can be standardized. **When you add Einstein's** discovery of relativity and the different uses of the word *time*, you get an abstract and complex concept that inspired me to make this piece.

I used lacy cloth, words and images clipped from magazines, decorative papers, sheet music, clock parts, and encaustic paints applied in layers and fused together with a flatiron and a heat gun. To prevent the heavier bronze clock parts from falling off the panel, I secured them with brass wood screws.

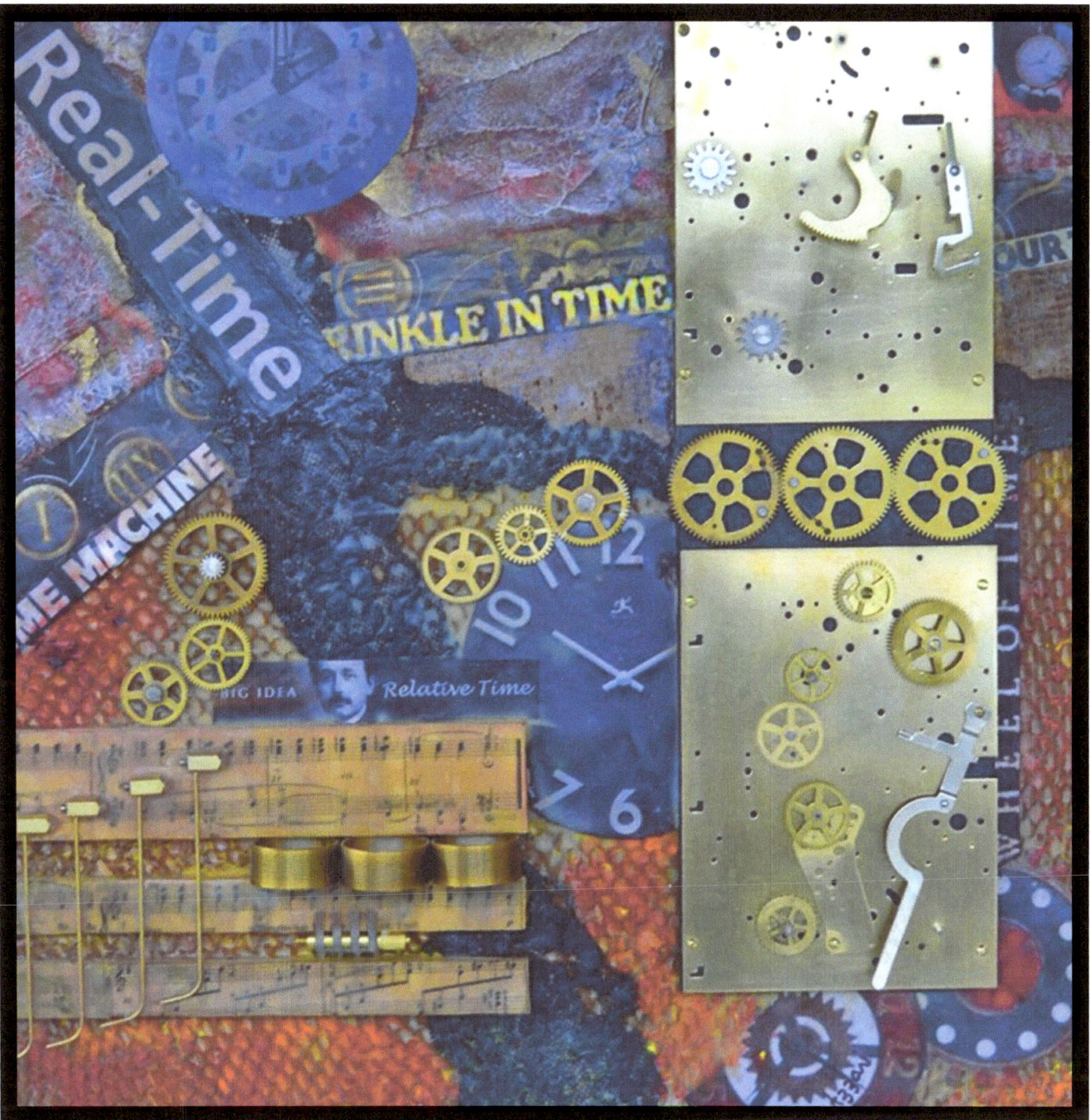

International Symbol of a Bear in Distress

22" x 22"

Encaustic Mixed Media Collage

This collage was a fun piece to create. It started when I found a tin mobile in a thrift store. It included a bear, several stars, and a pine tree. I took the mobile apart and immediately thought of all those jokes about a bear in the woods. I looked through my stuff and found a piece of rough wood, decorative papers, and specialty bark paper in addition to the tin pieces. As I played around with a symmetrical composition, I laid in the background using encaustic medium and colors over the specialty papers. I built the background in three layers, fusing them together as I went. I then added the rough wood and secured it with small finishing nails.

At this point, it occurred to me that I should make a statement in support of preservation and environmental concerns. I cut the tin bear into strips and used small finishing nails to attach them upside down. I wanted to indicate that the bear was injured. I completed the piece by attaching the stars on a dark-blue area at the top of the piece, and then I cut the tree in half and mounted the halves on the sides of the piece.

If this work can be equated to a flag flying upside down, the title is both serious and tongue-in-cheek.

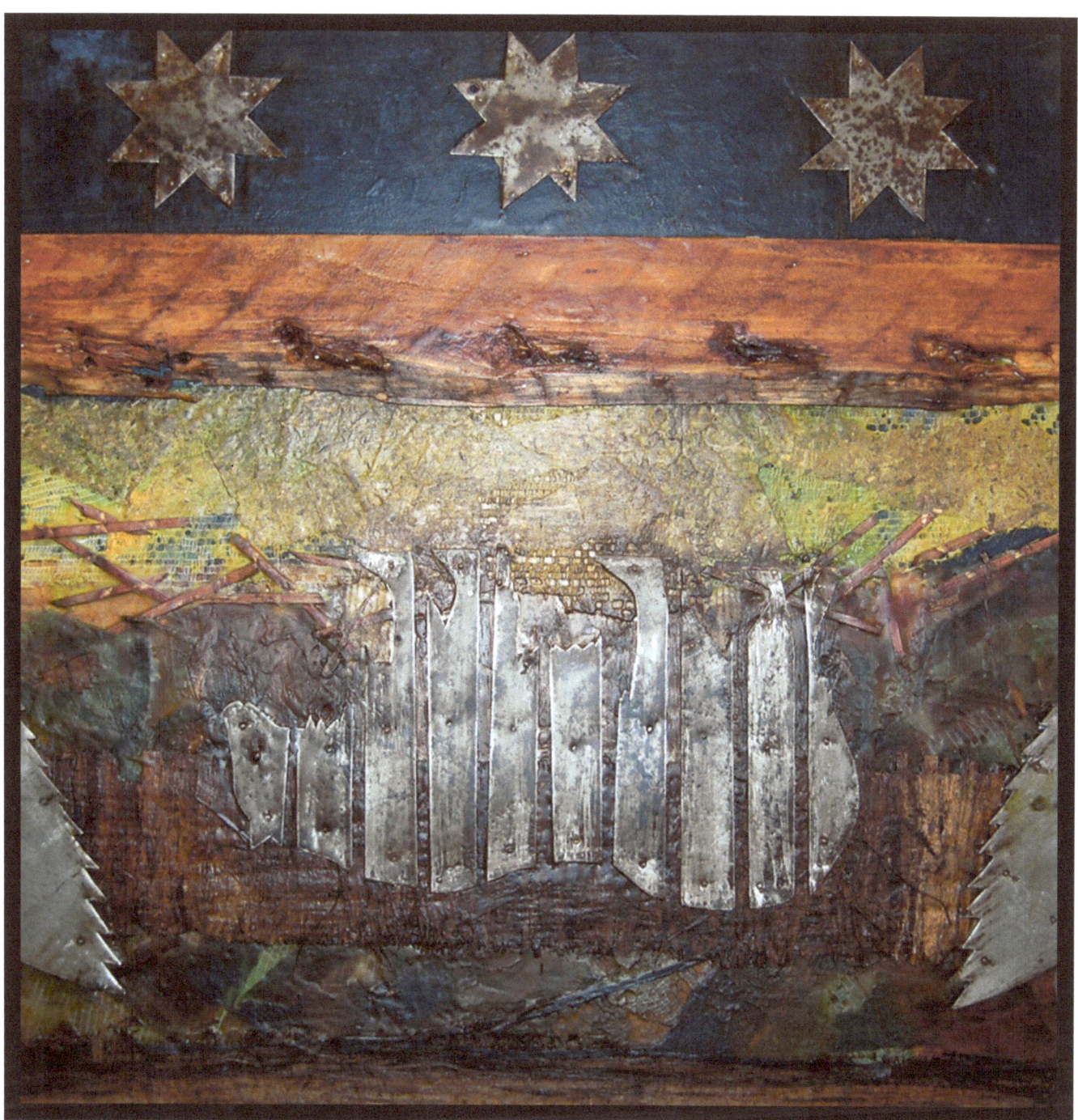

Class of 64

36" x 42"

Encaustic Mixed Media Collage

Class of 64 reflects on events that occurred when I was a senior in high school; the single most compelling event of this time was the assassination of President Kennedy on November 22, 1963. The event not only impacted my classmates and me but also stunned the world. Therefore, it is prominent in the collage. I included a few other iconic images that reminded me of my experiences in 1964, such as the word "Marlboro" and advertisements for Coca-Cola and Volkswagen. These elements represent the many days when, after school, my friends and I drove our parents' Volkswagen cars to the local soda fountain. We each drank a Coke while we tried to hide the Marlboro cigarettes we were smoking.

I did a lot more surface painting in this piece as opposed to collage. Before adding any pictures or words, I laid down a base section of Rubbermaid shelving, two sections of heavy cardboard, metal rectangles of different sizes, and decorative papers. These preparations added surface texture, which was enhanced as I applied and blended the colored encaustic paints. I added the magazine clippings at the end, blending them into the background. My last step was to apply a clear coat of encaustic medium over the entire composition and fused it with the underlying layers of wax.

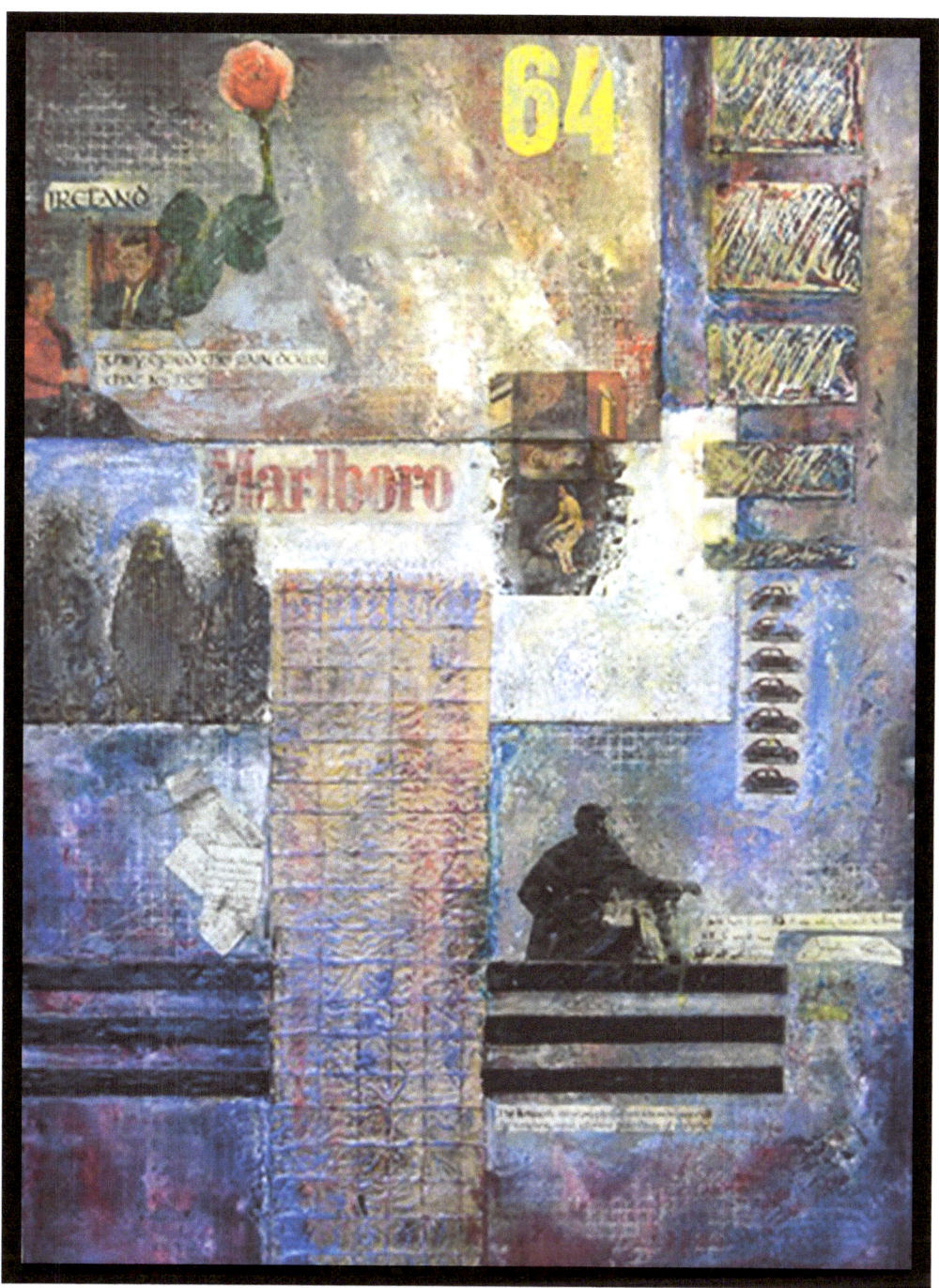

Underwood

22" x 22"

Encaustic Mixed Media Collage

Underwood is a study of geometric shapes, made using decorative papers. The biomorphic shapes of the raw wood were an unplanned addition. The wood contrasts the formality of the rectilinear shapes. I selected the decorative papers for their colors and textures, which add interest and variety to the surface of the work. I encased the papers within the wax and attached the wood pieces with finish nails. To complete the piece, I added a clear coat of encaustic medium, fused it to the layers below, and buffed it with a shoe brush after the wax set for a few days. In fact, I buff every piece I create to eliminate the natural hazing (blooming) of the wax as it sets up.

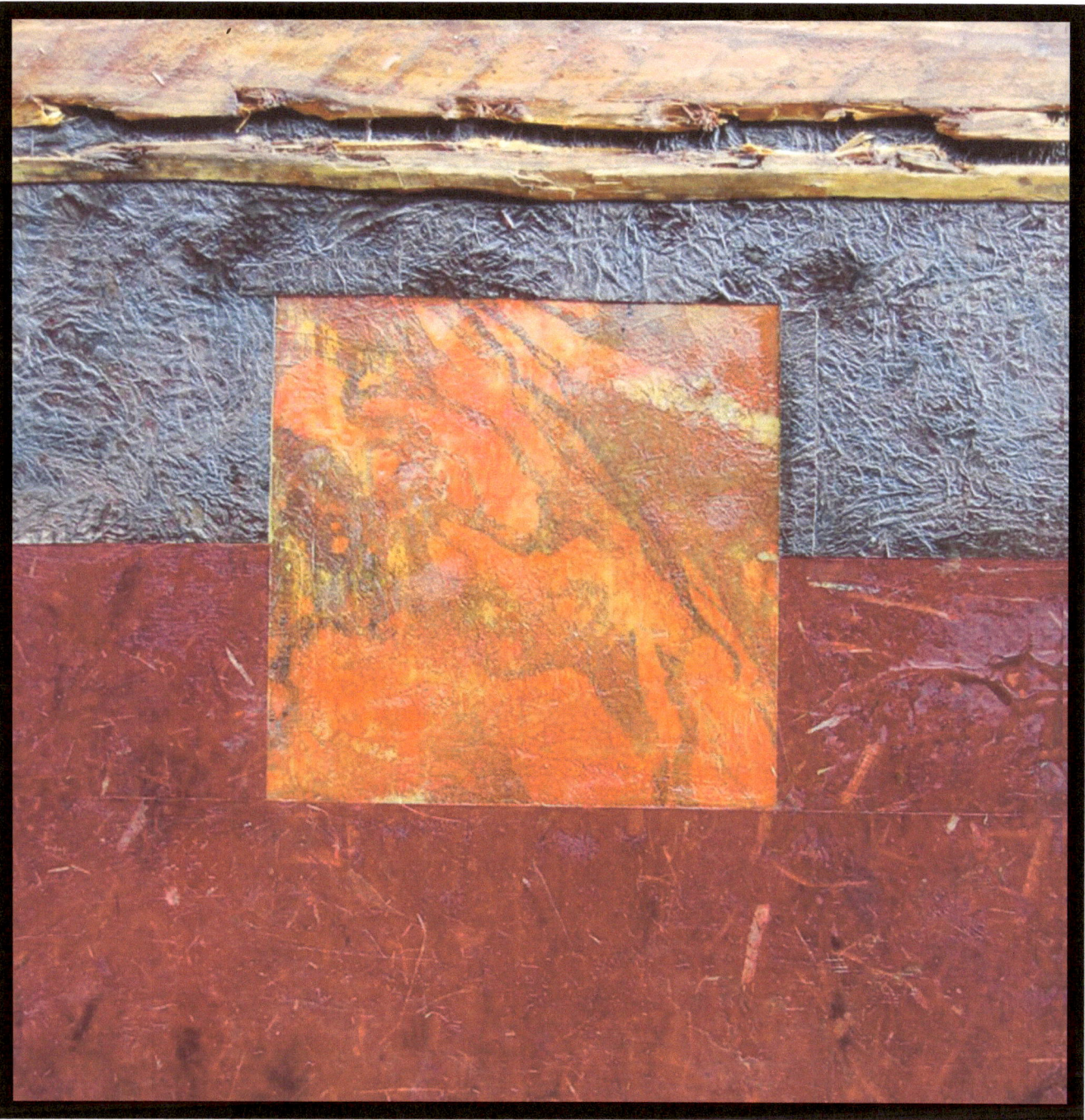

Hands of Mud, Love, and Faith
22" x 22"
Encaustic Mixed Media Collage

I created *Hands of Mud, Love, and Faith* for a local show in Taos, New Mexico. The subject matter for the show was a celebration of the famous San Francisco de Asis Mission Church, located in Ranchos de Taos; it's considered the most painted church in New Mexico. I did extensive research into the history of the church and its patron saint, Francis of Assisi.

Saint Francis was a wealthy Italian man before he dedicated himself to God. He gave up all his worldly possessions and devoted himself to a humble life of poverty and helping the poor. He also had a vision while recovering from an illness, in which he heard the message: "Francis, go repair my church, for it is nearly falling down."

The church was originally built, arguably, in the mid-1770s. It was used not only for worship but also for protection from various hit-and-run attacks from Native American tribes. Over the years, the church fell into disrepair. Many of the original adobe bricks were destroyed by moisture, and the adobe outer coating had crumbled away. However, repairing the church was hindered by a lack of funds in the poor parish.

In 1979, the congregation, in the spirit of Saint Francis, voted to rebuild and repair the church. Volunteers gathered and stripped off the adobe topcoat and made new adobe bricks to replace the damaged and broken ones with their own hands. Over a span of a couple of years, they completely restored their bricks and coated the entire church with a new topcoat of adobe mud. Through dedication and love for their church, they keep the church in good repair by replacing the topcoat every two years. The endeavor was truly an act of love stemming from their faith in the teachings of Saint Francis.

During the creation of this piece, it was important to me that I portrayed the essence and meaning of Saint Francis as well as the devotion and love the parishioners demonstrated for their church. Consequently, the images and words I selected for this collage reflect the spiritual love inspired by Saint Francis that led his flock to rebuild the mission church with pride, love, and faith.

Reference: Wolfgang Pogzeba *Ranchos De Taos: San Francisco De Asis Church*, 1st ed., Wolfgang Pogzeba Lowell Press, 1981.

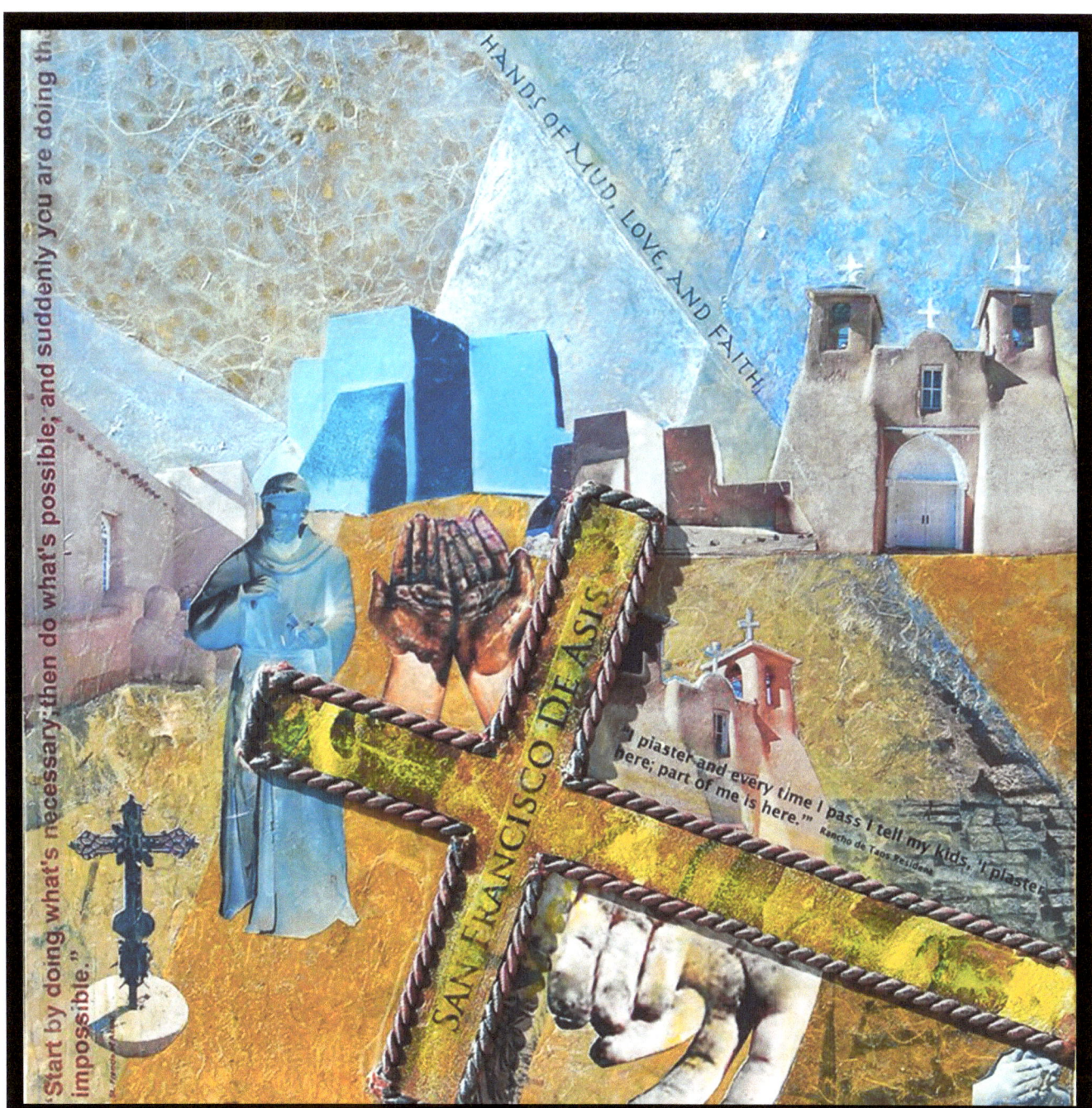

Not Another Flag Painting

22" x 22"

Encaustic Mixed Media Collage

Anytime an artist uses red, white, and blue in a piece, those viewing it may consciously or unconsciously think of the American flag. *Not Another Flag Painting* is just that, not a flag painting. I have always thought red, white, and blue to be a beautiful color combination. This piece is a study of these colors and what happens when a metallic bronze color is introduced in combination with them. The bronze interacts in a slightly different manner when applied over the other three colors. The well-known artist and colorist Josef Albers calls this interaction among colors "color deception." While other colors would illustrate this phenomenon more dramatically, the bronze does appear slightly different on the other colors than it would alone.

Colors aside, this painting is another study of basic shapes and differing textures. I placed different kinds of cloth and textured paper below and above the colored areas, especially in the white area. I applied the elements of the collage with clear and colored wax in the same way as for other pieces.

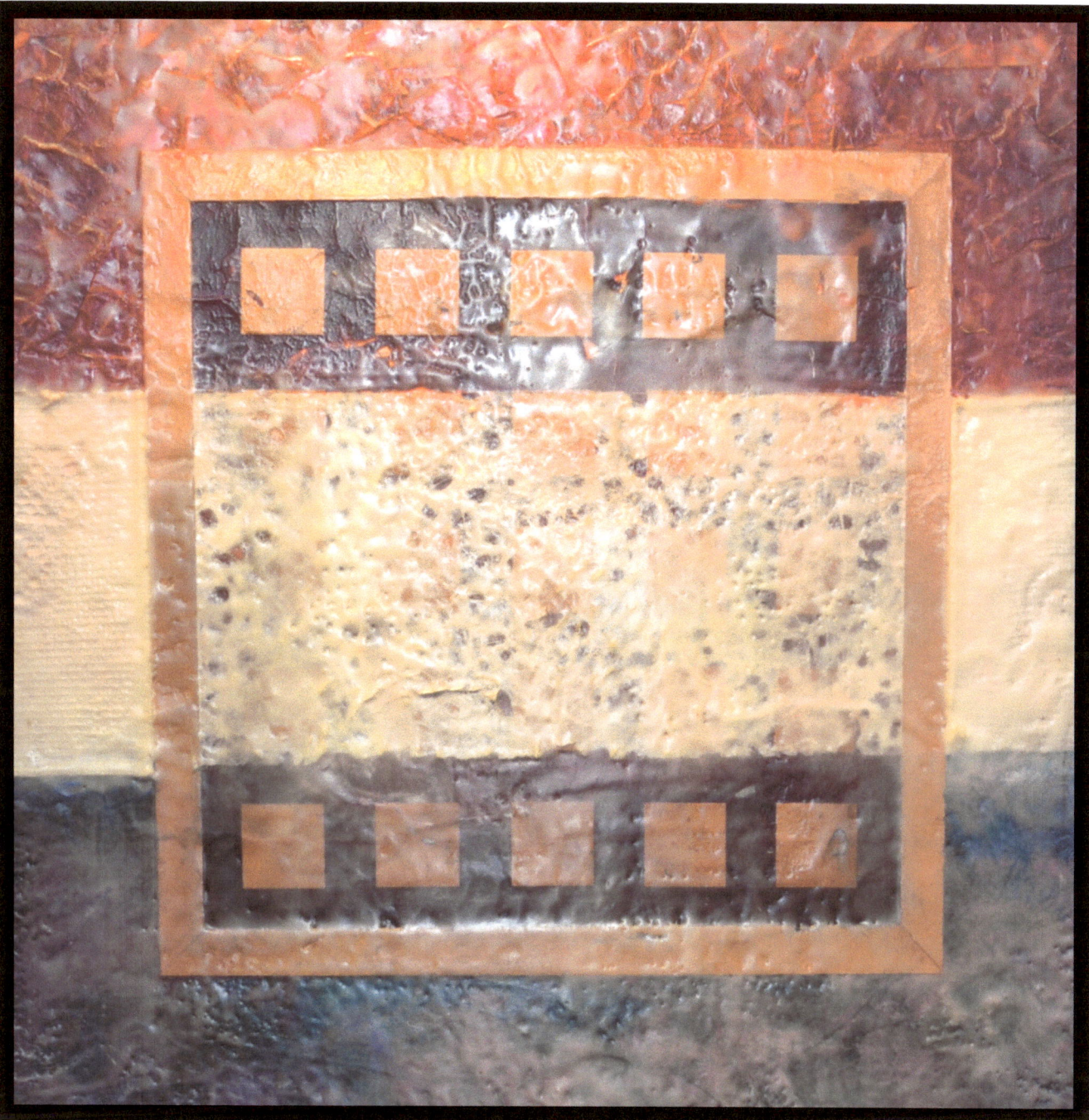

Letters and Numbers

6" x 6" Each Panel

Encaustic Mixed Media Collage

I created *Letters and Numbers* for a miniature show sponsored by the Millicent Rogers Museum in Taos, New Mexico. My interest in visual and tactile textures again dominates the work. By placing the letters and numbers on different layers of the medium, colored and uncolored, a degree of transparency was achieved. The dominant black shapes are applied cloth; I added gauze material on some layers to create unusual textures.

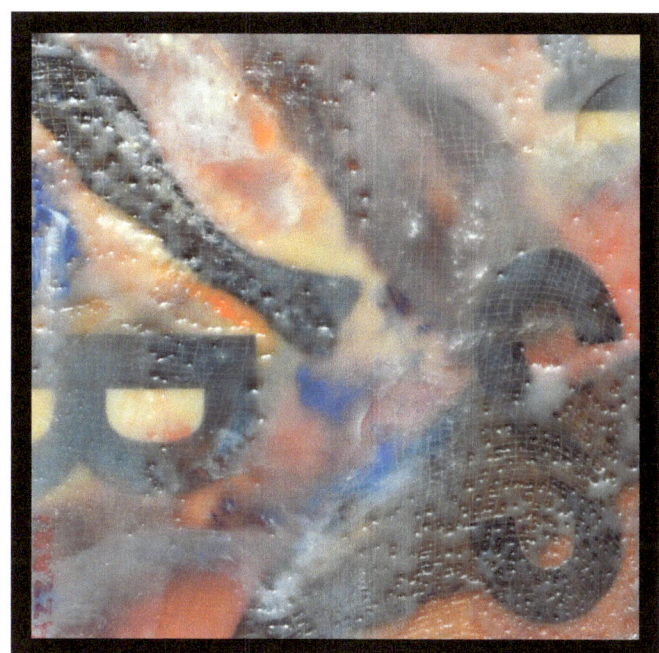 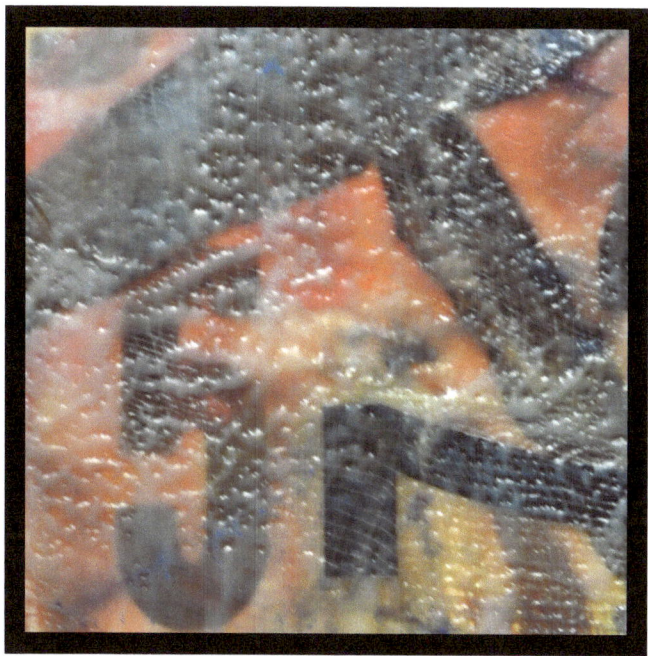

Grid

12" x 12"

Encaustic Mixed Media Collage

After I created *Underwood*, I made two other paintings in which I experimented with geometric shapes and papers of different colors and textures. In this piece, I chose four types of papers: paper made of bark, black paper covered with circles, orange-and-yellow paper, and darker orange paper with a grid. This study, using essentially the same composition as *Underwood*, demonstrates how using different elements of color and texture can transform something into a completely different work of art.

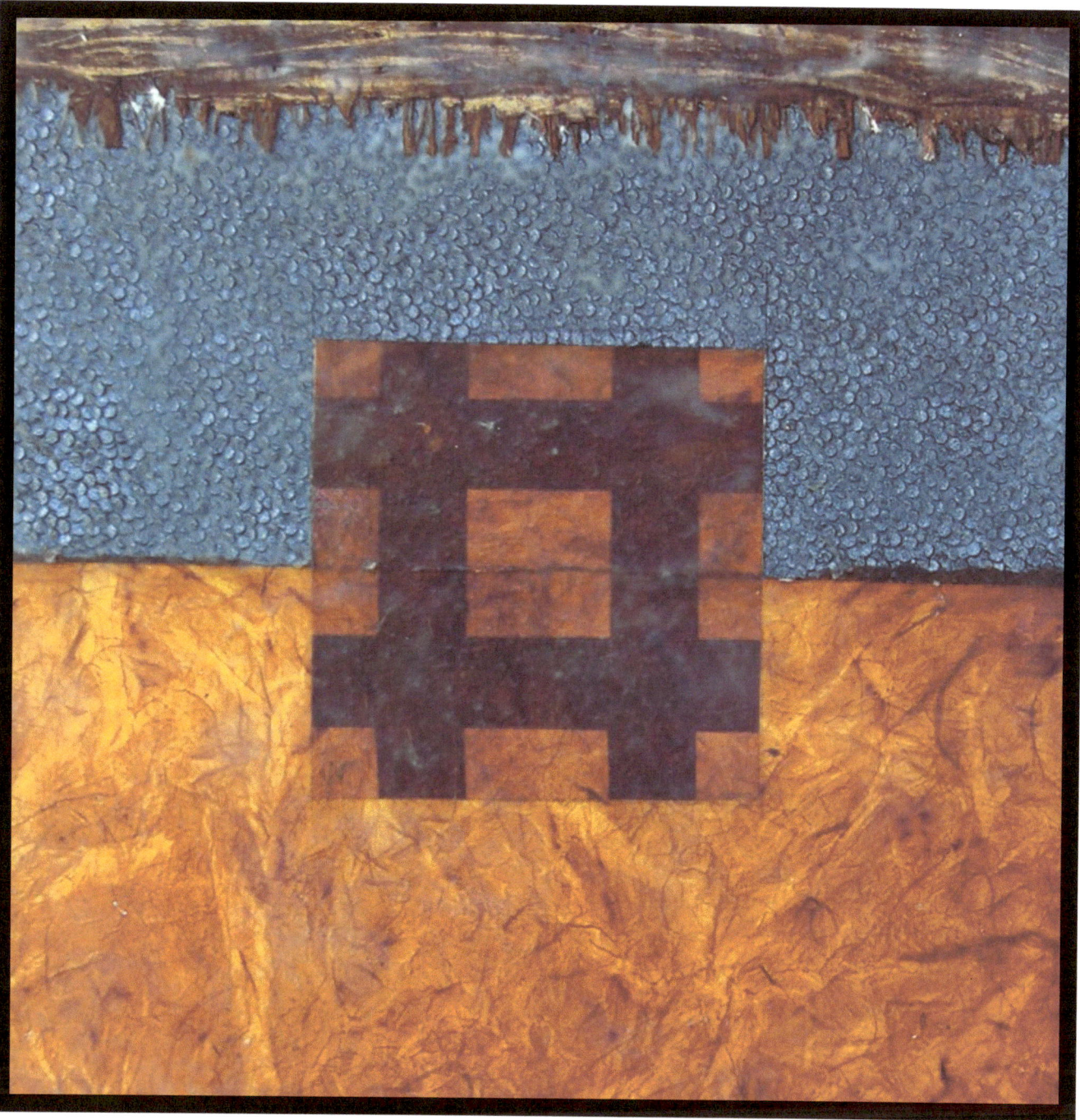

Underwood 2

12" x 12"

Encaustic Mixed Media Collage

As mentioned in the description of the previous collage, after I created *Underwood*, I made two other geometric paintings to experiment with geometric shapes and different papers of colors and textures. The rationale for *Underwood 2* is exactly the same as *Grid,* the previous work.

I chose several types of paper to create this work, one made of reds and orange fibers and two shades of yellow speckled paper. I let the green encaustic paint below seep through darker yellow paper to create more visual interest. The dark red brown square in the center was a mixture of red paper with brown encaustic paint seeping through from below and some additional paint added on top giving the square a leather look. Nailing some leftover wood from the original *Underwood* topped the piece.

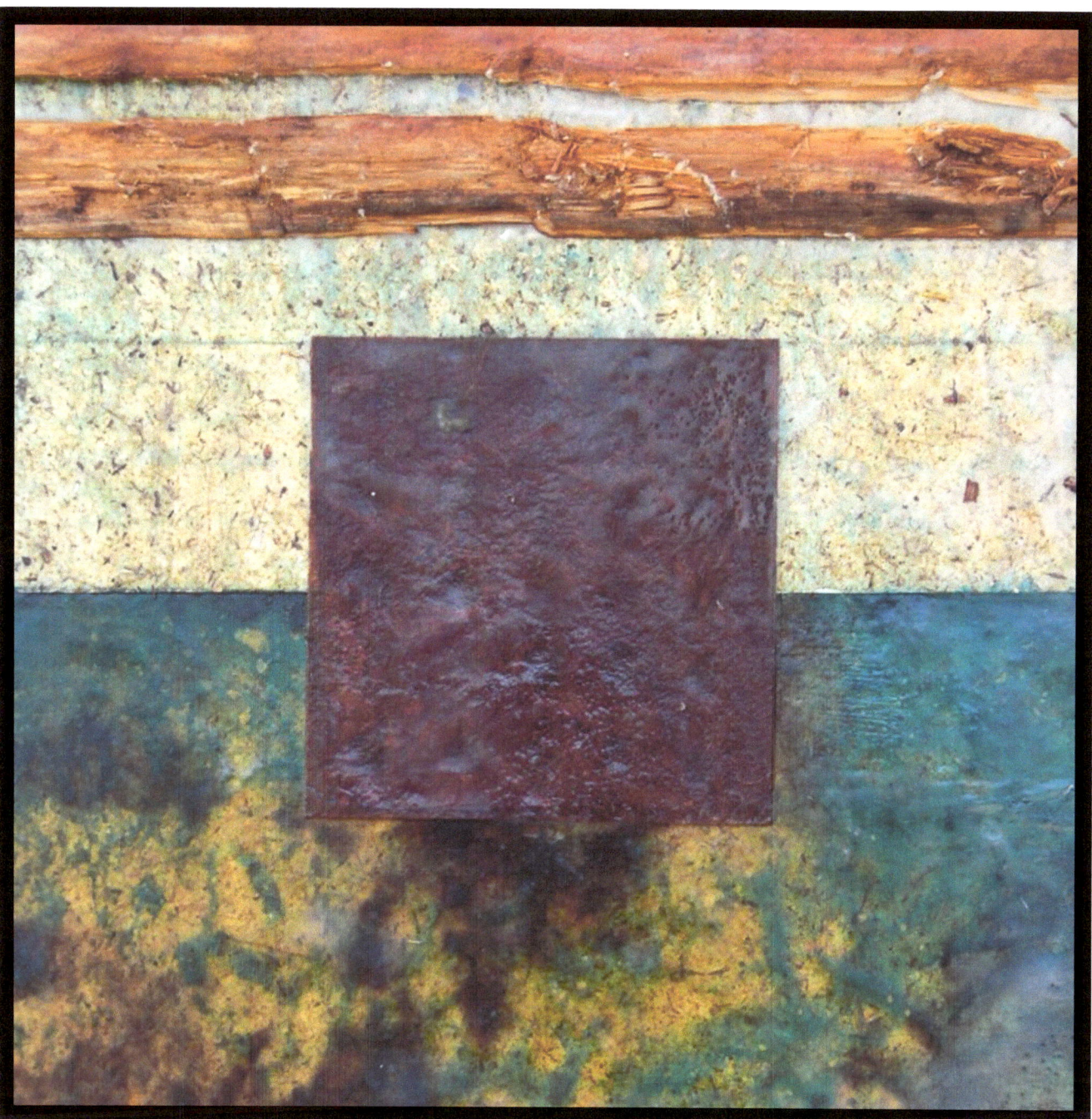

50 Points

11.5" x 14"

Encaustic Mixed Media Collage

This piece, *50 Points*, is a commentary on the fact that we get points for almost everything we buy. We accumulate frequent flyer miles, points from certain supermarkets to get discounts on gasoline, points for using a credit card, points for education, and so forth. Companies throughout the world use this marketing strategy. Consumers may assume that these points are free, but they pay for them through hidden cost increases and tax deductions the companies use to reduce or eliminate tax liabilities.

I housed my social commentary within an abstract composition. Each dowel symbolizes one point, while the word and number are self-explanatory. I took apart a glass candlestick and used two pieces as frames. I also painted with colored encaustic medium, including metallic silver in some places. A piece of rubber shelving protector was used as well. Finally, I mounted the finished piece onto another panel covered with aluminum tape to create contrast.

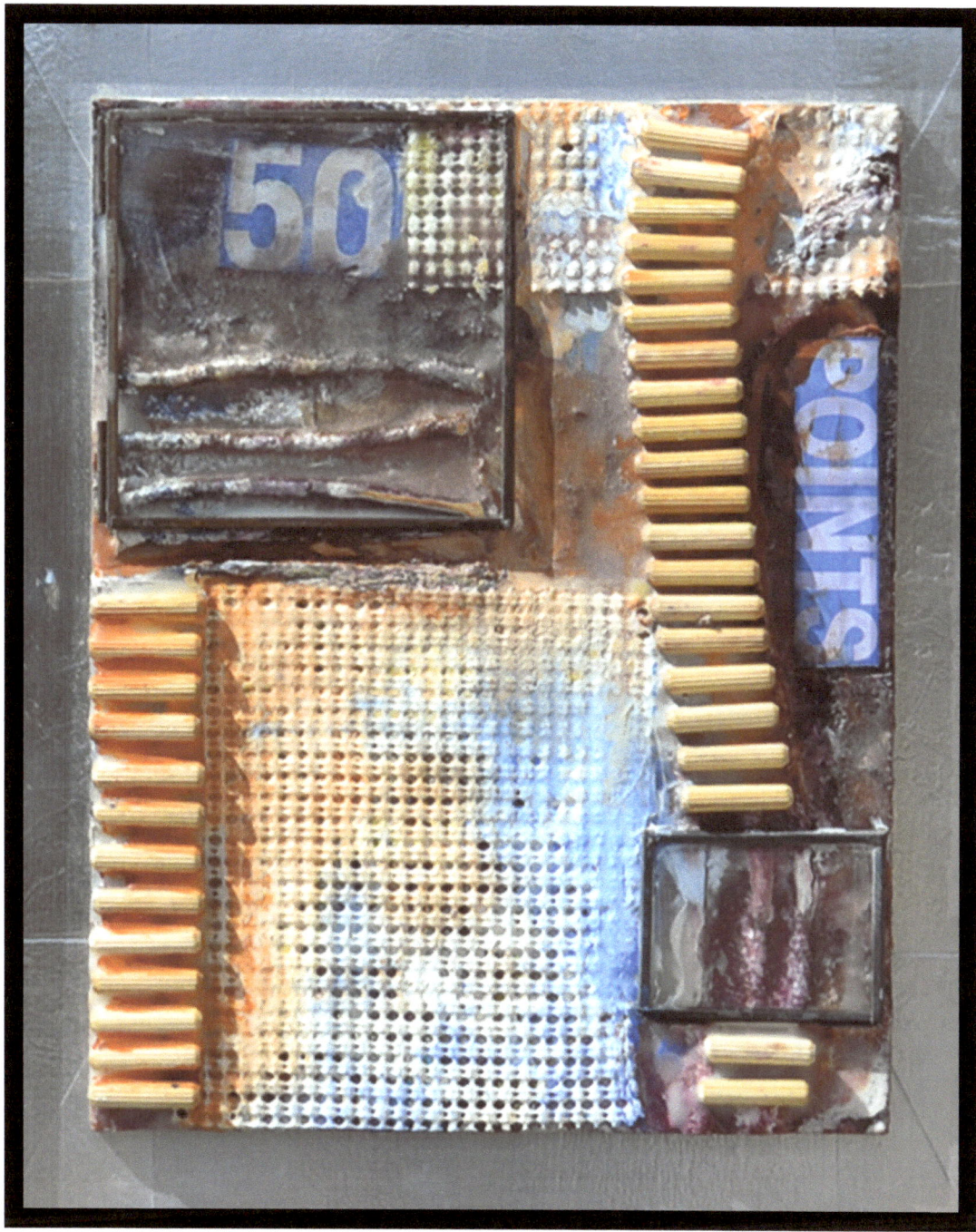

Equality

12" x 12"

Encaustic Mixed Media Collage

At times, the meaning of my art can be obscure to the viewer. This piece, *Equality*, is probably one of those works. The background is a piece of variegated paper with slices of wood imbedded. I applied it to the surface with a clear encaustic medium. The photo of a woman was manipulated on the computer, transforming the black-and-white image into an array of spike like pixels. The bronze leaves were found at a local thrift store; they are attached with tiny screws and wax medium. The round bronze object with slots is the cover of an industrial floor drain.

The title of a piece of contemporary art is very important, especially when the artist uses symbolism. Examples of symbolism can be found in every era of art, including pieces made today. One such example is found in Marc Chagall's painting, *Time Is a River Without Banks*. The painting includes a prominently depicted river, with a pendulum clock and a fish with wings dominating the center, from top to bottom. The winged fish is a symbol of Christ fleeing the world. The pendulum represents humankind's destiny (in many paintings, a pendulum also represents the crucifixion). The river is the source that animates life of all nature.

My title, *Equality,* refers to my comment through this piece as what is described as the war on women. The enhanced image of a woman represents the fracturing of women's rights during the last ten years, the leaves symbolize femininity, and the drain represents where those rights are going.

Reference: Matilde Battistini, translated by Stephen Smith. "Symbols and Allegories in Art" Los Angeles: The Getty Museum, 2005).

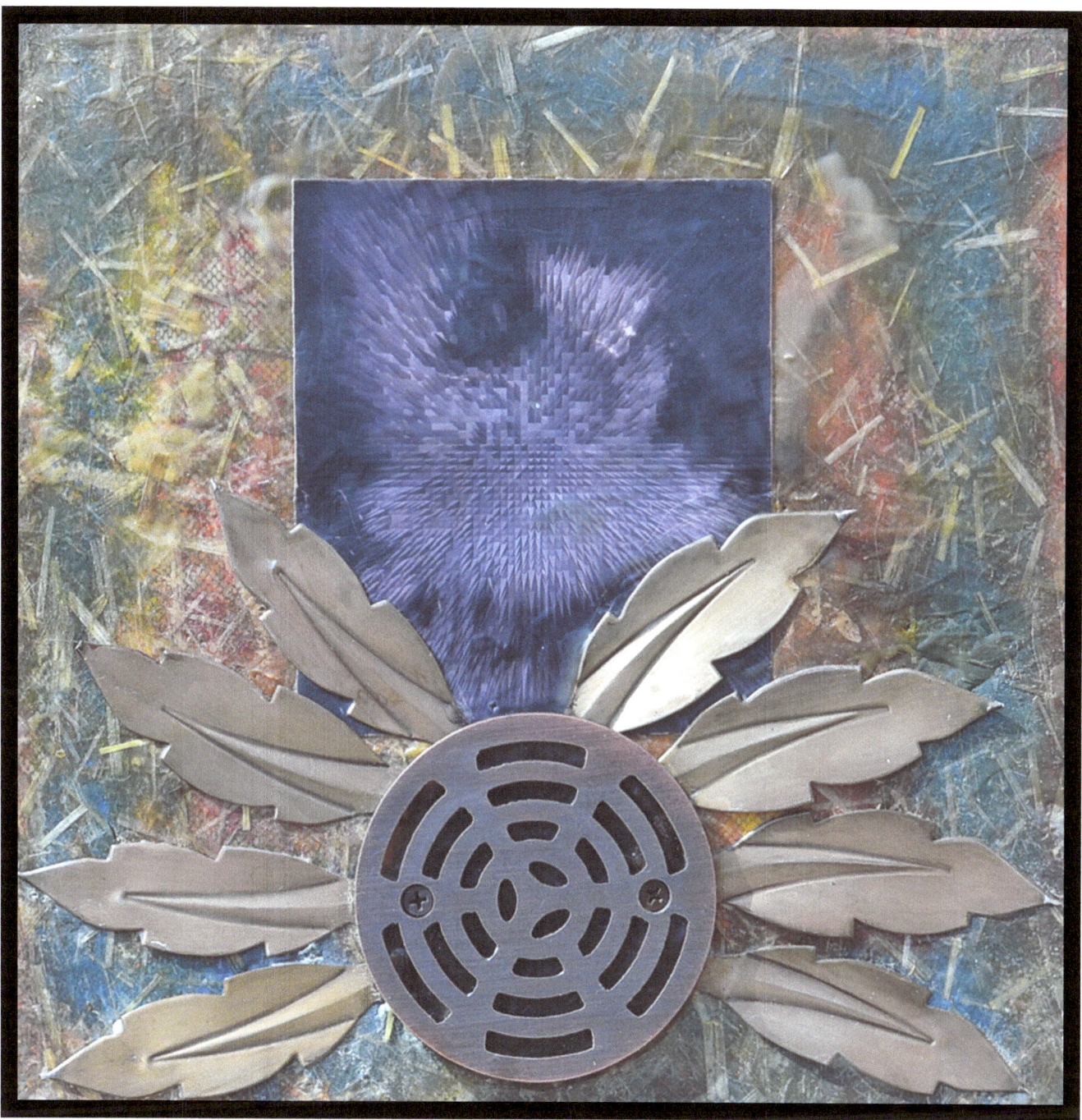

Yes, Virginia, Climate Change Is Real
18" X 24"
Encaustic Mixed Media Collage

The fossil fuel industry has an economic stake in denying that the human race caused global warming and that it is a real threat to the environment and the future of humankind. Despite the overwhelming amount of worldwide scientific evidence, the industry provides studies that were conducted by scientists funded by fossil fuel producers; the results counter or cover up scientific findings. Through making political donations to various politicians and releasing misleading advertisements, these fuel companies have created a vocal minority that believes—or has been paid to believe—that global warming is a hoax. *Yes, Virginia, Climate Change Is Real* is my humble contribution to the cause of slowing down or reversing the effects of this dangerous phenomenon.

I did a few new things in the process of creating this piece. I used store-bought vinyl letters and painted over them with colored encaustic medium. I then removed the vinyl letters to expose the bottom color in the shape of the letters. I also inscribed circles on the top and bottom of the work. These techniques created interesting textures and color variation. Applying several layers of paper, cloth, and both colored and uncolored wax medium created the background between the lettering. I finished the composition by applying relevant royalty-free images from the Internet.

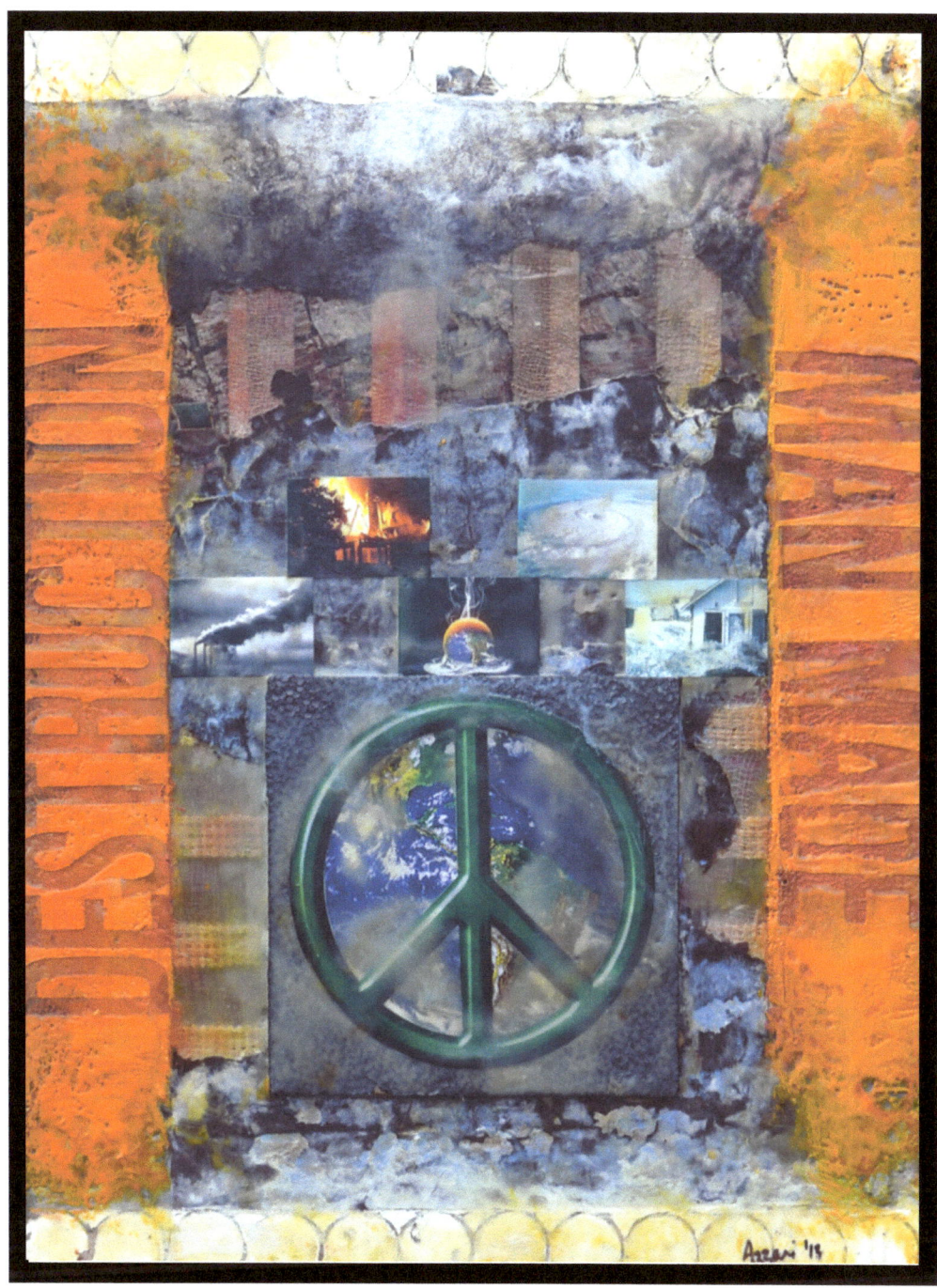

Appendixes

1. Encaustic Tips

2. Resources

3. Biography

Appendix 1: Encaustic Tips

I am not giving step-by-step instructions on how to make an encaustic painting; there are several excellent books that provide such information. My favorite, available on Amazon, is *The Art of Encaustic Painting* by Joanne Mattera. Instead, I will discuss the media, equipment, and tools you will need to begin to create your own wax paintings.

Starter kits of various price levels are available online. They include premixed sticks of colored encaustic wax, premixed encaustic medium, some basic tools, instructions, brushes, and a small electric flatiron. Before I purchased professional tools and equipment, I started out with an inexpensive beginners' set. If you decide that encaustic painting is for you, you can try the commercially available tools and equipment and inexpensive alternatives that work just as well.

Encaustic Media:

As I mentioned earlier, some artists create their own formulas, using different types of wax, linseed oil, and dammar resin. The basic formula I use consists of beeswax (I use the pure-white pharmaceutical grade) and crystallized dammar resin, made from tree sap. I mix four parts wax to one part resin. These ingredients come in one-pound and five-pound bags. You can buy these ingredients either online or at an art supply store. One-pound bags run about eleven dollars each. Larger bags are cheaper by the pound. Because encaustic paints need to be molten when used, you need a heat source and a metal container large enough to hold a decent batch of the wax medium. Options:

1. A hot plate and a plain metal pot (not the best choice).

2. A two-quart or larger inexpensive electric slow cooker with low, medium, and high settings. This option is better because it offers better heat control and will probably cost less.

3. A candy thermometer is a good investment, used to ensure that the wax is within workable range and not too hot.

4. An ordinary wooden kitchen spoon and a ladle are needed to stir the mixture and to transfer the medium to smaller containers.

Coloring Pigments:

After you have made a batch of the colorless encaustic medium, you will want to create small batches of colors to create your encaustic palette. You will need the following:

1. Small tin cans, such as empty tuna cans. You can buy tin cans online in various shapes and sizes; however, buying tins from encaustic supply companies is much more expensive than purchasing them from tin manufacturers.

2. You can buy ground pigments at an art supply store or online. They are expensive but last a long time. Using oil paints to color the wax medium is a good alternative to these pigments, and is less expensive.

3. You need a heat source to melt and mix the pigment with the medium.

A. An inexpensive electric griddle works extremely well and provides enough area to serve as a mixing palette. Commercially designed encaustic palettes can cost more than five times the cost of a pancake griddle.

Of course, if you are willing to pay the price, there are several suppliers of pre-made colors which are sold in tins or in stick form. Just place them on your heated palette, and they will melt and be ready to mix or use. Encaustic suppliers are listed in the appendix under resources.

Safety Note: It is important to keep from overheating your encaustic medium or colors. The dammar resin in encaustic paints causes them to smoke if overheated. This smoke is slightly toxic, so avoid long exposure. In addition, overheating breaks down the integrity of the medium and may cause it to crack. It is best to work in a ventilated area. The safe working temperature ranges between 180 and 200 degrees F.

Tools and Equipment

There are many options for acquiring the tools and equipment you will need to get started. You can shop at discount department stores, thrift stores, and even garage sales if price is a factor in your choices. If price is not as much of a concern, everything you need is available online or at art supply stores at a premium. After I decided I wanted to keep doing encaustic painting, I began to purchase more expensive tools and equipment. However, in some cases the inexpensive versions work just as well. This is the case for bristle brushes, especially wide ones. Cheaper alternatives, sometimes of better quality, can be purchased at a hardware store. A list of some of the things you will need to get started follows.

1. An adjustable-temperature heat gun. These cost between ten and fifteen dollars at a hardware store or thirty dollars or more from an art supplier. You need this to fuse layers of wax together and to create effects in the wax.

2. A flat electric iron, not a steam iron. Used for the same processes as the heat gun, but produces different results.

3. Optional: a wood burner (as found in a wood burning set). This is used to create lines and shapes in the wax.

4. Narrow and wide putty knives for scraping.

5. Ceramic tools good for scraping, incising, and shaping the wax.

6. Spring-type clips to move your tins around on the palette.

7. A retractable utility knife to trim wax and other items you apply to the wax.

8. An eighteen-inch metal ruler. It is easier to clean the wax off a metal one.

9. Bristle brushes an assortment from very thin to two inches wide.

10. Cakes of soy wax to clean brushes. Much cheaper than beeswax.

11. A caddy to hold your tools.

12. A work table in a well-ventilated area.

13. Any tool you come across that will add texture or can be used to scratch or scrape the wax (e.g., forks, knives, spoons, and so on).

14. An extensive supply of paper towels to clean your palette, work surface, and tools.

15. Surgical gloves to keep your hands protected and clean.

Painting Surfaces and Panels

When working with encaustic paint, you must use a rigid and absorbent surface. Because canvas expands and contracts during temperature changes, using these paints on canvas supported with only stretcher bars will cause the wax to crack. Some artists glue canvas to a board so it remains rigid and stable and thus suitable for encaustic paints. There are also commercially available primed boards made especially for encaustics. These boards are available either cradled or not cradled. A cradled board is trimmed with small strips of wood on the outer edges of the underside. Make sure that the board you purchase is labeled for encaustics and not acrylic or oil paint. The primed surfaces of these boards are not absorbent, and wax paint will not adhere to them. Commercially prepared boards are very expensive, and there are alternatives.

The lumberyard is an encaustic artist's best friend. You can purchase a four-by-eight foot sheet of quarter-inch birch or lauan plywood for what it costs to buy four eight-by-ten-inch primed encaustic panels. You can have the yard employees cut the plywood into any size. I like to cradle my boards, even though you do not need to, so I buy several lengths of three quarter inch by one inch pine board. The birch plywood does not need to be primed.

I often put a coat of uncolored media over the entire surface of the board and fuse it to the board with my heat gun. The primed, commercially made board looks prettier, but plywood is just as good and much more affordable. The money you save can be used to buy your wax and tools.

Appendix 2: Resources

The following lists are just a sampling of the many resources available. There are many videos available on YouTube. Most are offered by artists, encaustic manufacturers, and tool suppliers. I have found that even inferior videos have provided me with something I did not know about the medium.

Encaustic Books:

Kelly, Kassandra. *Encaustic Materials Handbook*. Oregon City: Leland Iron Works Press, 2013.

Mattera, Joanne. *The Art of Encaustic Painting*. New York: Watson-Guptill Publications, 2001.

Pratt, Frances and Becca Fizell. *Encaustic Materials and Methods*. New York: Lear Publishers, Inc., 1949. Out of print. Visit the **Frances Pratt** website (http://francesprattart.com) for updates about this little-known artist, writer, and collector.

Rankin, Lissa. *Encaustic Art: The Complete Guide to Creating Fine Art with Wax*. New York: Watson-Guptill Publications, 2010.

Seggebruch, Patricia Baldwin. *Encaustic Mixed Media: Innovative Techniques and Surfaces for Working with Wax*.

Stavitsky, Gail. *Waxing Poetic: Encaustic Art in America*. Montclair, New Jersey: The Montclair Art Museum, 1997.

Woolf, Daniella. *The Encaustic Studio: A Wax Workshop in Mixed Media Art*. Loveland, Colorado: Interweave Inc., 2012.

> *Safety Note: Remember, you will be working with melted wax and very hot tools, so be careful when handling them. Wear protective eyewear and use spring clips or folded paper towels to move tins on and off your palette. Take care not to splash the hot wax.*

Encaustic Supplies:

Ampersand Painting Panels for Artists: http://www.ampersandart.com/index.html

Dick Blick Art Supplies: http://www.dickblick.com/

Earth Pigments: http://www.earthpigments.com/indexcfm

Encaustic Supplies: http://encausticsupplies.com/

Enkaustikos: http://www.encausticpaints.com/

Natural Pigments: http://www.naturalpigments.com/shop_main.asp

R and F Handmade Paints: http://www.rfpaints.com/

Ruhl Bee Supply: http://www.ruhlbeesupply.com/

Swan's Candles bulk beeswax and other encaustic supplies: http://www.swanscandles.com/store/encausticsupplies.html

Organizations:

All Things Encaustic: Encaustic Art Blog and Directory: http://encausticartist.com/

Encaustic Art Institute: http://eainm.blogspot.com/ (online monthly magazine) Encaustic

Artists: http://www.facebook.com/Encaustic.Artists

International Encaustic Artists: http://www.international-encaustic-artists.org/

NW Encaustics: http://www.nwencaustic.com/artists.html

The Encaustic Center: http://theencausticcenter.com/index.html

Appendix 3: Biography

Ken Azzari
e-mail: artist1011@me.com
website: kenazzariart.com

BA in art at California State University, Northridge

MA in education at California State University, San Bernardino

Art director for TV and motion pictures for five years

Art teacher and school administrator, retired

Full-time artist, 2008 to present

Taos Center for the Arts self-portrait juried group show. January and February 2010

ArtSlant Online Fine Art showcase awards January, February and March 2010

Touchtone Gallery, Taos, NM, juried show, August and September 2011

Taos Fall Arts Festival, Taos, NM: Taos Select, juried art show, October 2011

I Have the Right, CSU, Dominguez Hills, Picture Art Foundation juried group show November 2011–July 2012.

Biography Continued

Tenth Annual Miniature Show and Sale, Millicent Rogers Museum Taos, NM, February 2012

LaGrange National XXVI Biennial, LaGrange Art Museum, LaGrange, Georgia, juried group show February 10, 2012–April 20, 2012

Studio Visit magazine, juried acceptance, published 2012

World Wide Art Books, juried acceptance, published 2012

International Contemporary Masters, Vol. V, juried acceptance, published 2012

Taos Fall Arts Festival, Taos, NM: Taos Select, juried art show, October 2013

www.ingramcontent.com/pod-product-compliance
Lightning Source LLC
Chambersburg PA
CBHW050814180526
45159CB00004B/1665